GIRLHOOD

First published 2023 by order of the Tate Trustees by Tate Publishing,
a division of Tate Enterprises Ltd, Millbank, London SW1P 4RG
www.tate.org.uk/publishing

A catalogue record for this book is available from the British Library
ISBN 978 1 84976 863 4
Distributed in the United States and Canada by ABRAMS, New York
Library of Congress Control Number applied for

Senior Editor: Alice Chasey
Series Editor: James Finch
Production: Roanne Marner
Picture Researcher: Roz Hill
Designed by Narrate + Kelly Barrow
Colour reproduction by DL Imaging, London
Printed in Wales by Cambrian Printers

Front cover: Francesca Woodman, *Space², Providence, Rhode Island* 1976
(detail), photograph, gelatin silver print on paper, 14 x 14, Tate

Measurements of artworks are given in centimetres, height before width,
before depth.

GIRLHOOD

CLAIRE MARIE HEALY

Director's Statement

'Look Again' is a bold new publishing programme from Tate Publishing and Tate Britain. In these books, we are providing a platform for some of the most exciting contemporary voices writing today to explore the national collection of British art in their own way, and reconnect art to our lives today. The books have been developed ahead of the rehang of Tate Britain's collection, which foregrounds many of the artworks discussed here. In this third set of books – *Death* by Sean Burns, *Strangers* by Ismail Einashe *Girlhood* by Claire Marie Healy, and *Faith* by Derek Owusu – we are offered unique perspectives on a wide range of artworks across British history, and encouraged to look closely, and to look again.

Alex Farquharson, Director, Tate Britain

The girls were always everywhere. They have been with me and around about; they wait in the wings, in their hundreds, their thousands. I've seen them inside gilded frames, peered at by girls on school trips, kohled eyes locking over centuries. I've seen them in the window displays of exclusive spaces which are the stomping ground not of schoolgirls, but the older art collector: all those men who have appreciated these renderings of innocent-looking damsels – or, rather, who appreciate the price they fetch. I've seen them looping and infinite, online, on screens (here, they move faster than anyone could catch hold of their skirt hems and give them a title). On search engines, their smiles are purchasable as a stock image; on social media feeds, girlhood is for sale in other, more subtle ways. Then the feed refreshes.

The annals of art history suggest their own anonymising title for all these girlhoods: *Portrait of a Girl*. Sometimes, she is a *Portrait of a Young Girl* or, chopped in two, a girl *at Half-Length*. When she is not a *Girl*, she is a *Miss*. *In Profile,* she avoids

our gaze; more often, she meets it head on. Her head and shoulders have been studied, modelled and sketched, painted, imaged, recreated. But among these infinite variations – this anonymous army of girls – some burn more brightly than others. Because there have always been those who seem to tell us something about what makes up our communal ideas of girlhood, girls who leap from the frame to speak with our own experience of it.

Here's one.

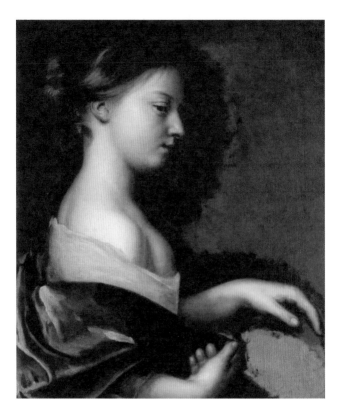

Mary Beale, *Portrait of a Young Girl* 1681, oil paint on canvas,
53.5 x 46, Tate

In this *Portrait of a Young Girl* 1681 by Mary Beale, the figure is totally anonymous. Anything that we know for sure about the painting renders it unremarkable: it was painted by Beale when her popularity was beginning to wane, and its muddy colours indicate it was most likely a testing ground for new painting methods. While we tend to imagine that any work framed in a gallery always aspired to its own greatness, this work was intended as nothing more than a quick sketch-in-oils of whichever pretty girl happened to be around – perhaps Beale's goddaughter, or even her studio assistant, whose work clothes you can imagine being hurriedly draped with the fabrics of finery. When we encounter this *Young Girl* in person, however, she begins to break the bounds of her making. The immediacy and informality of the sketch brings her out of one time and context, into our own. No longer an afterthought, the girl is a time-traveller. She side-eyes across aeons. What is she thinking?

A desire to give an identity to art history's many young female subjects has informed much curatorial thinking in the last decade. Whistler's copper-haired subject of *Symphony in White, No. 1* 1861–2 – actually seventeen year-old Irish immigrant Joanna Hiffernan – recently garnered her own exhibition at the Royal Academy. And the identity of Edgar

Degas's *Little Dancer Aged Fourteen* 1880–1, the three-feet-tall wax sculpture that the art world ridiculed on its debut at the Impressionist Salon, has been identified as Marie van Goethem, one ballerina among some hundreds of *petit rats* who rehearsed and performed at the Paris Opera; the global fame, and later multiplications in bronze, of Degas's sculpture read as bleakly ironic given how Marie's own life was so desperately circumscribed.

I am less interested in such biographical detail, however, than in approaching works with the tangible feeling of the encounter, to sift through the visual and uncover the girlhood/s from the girls.[1] It's a method inspired in spirit by a figure like Saidiya Hartman, who has used scant records of real lives as a springboard to illuminate 'the radical imagination and everyday anarchy of ordinary coloured girls, which has not only been overlooked, but is nearly *unimaginable*'[2] (my emphasis). If certain portraits of art history allow us to *imagine* girls' emotional and inner lives, it's because there exists in them something that speaks with our own. In this light, girlhood can be understood as less a prescribed length of time, more a way-of-seeing that never really leaves us.

I also want to consider how such images of girlhood have moved and changed hands. Portraits of girls,

which nowadays travel at hyper-speed online, have always circulated as objects of desire and value. Considered as such, the portraits of young royals like Marie Antoinette – whose fourteen year-old visage was sent across Europe to be judged by the French court and reproduced as miniatures or satirical sketches countless times in her reign – seem closer to pictures sent between boys' phones without girls' consent today than the images alone would ever suggest.

If girlhood is often thought of as a hole we drop into and scrabble out of by our nails – hoping that we might emerge into adulthood unscathed from all its events – then what happens if we drop into that hole, following one of its most recognisable products as we go? Not through, but perhaps *down*...

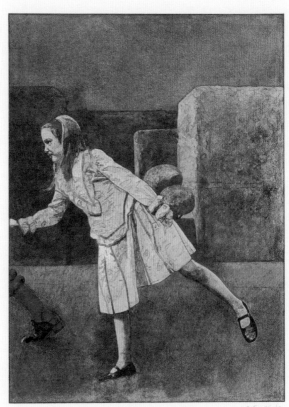

Peter Blake, *Just at this moment, somehow or other, they began to run*
1970, screenprint on paper, 24.3 x 18, Tate

Peter Blake's 1970 Alice, one of a series of illustrations for Lewis Carroll's *Through the Looking Glass*, doesn't deviate far from the established public image of the character: a girl so blonde, so Caucasian, so universally clad in the paraphernalia of girlhood (pleated dress, Mary Jane shoes, *Alice* band) that she sticks in our minds, principally, as a cartoon. Deriving from a children's story written about and for a *seven*-year-old girl, the character of Alice has experienced a kind of twentieth-century coming of age explicitly through the visual – an adolescence brought on by the artists, designers and filmmakers who have been inspired by her journey through a surreal, inhospitable universe and, I would wager, by the daring streak that separates the protagonist from the Victorian morals she's supposed to represent.[3] Alice, as the first art sensation designed explicitly for children – until Carroll's book, they were seldom considered as a separate category to adults at all – is not so much a girl as an idea that opens culture to a concept of girlhood in the first place.

With Alice, the groundwork is laid for a pattern that will continue in portraiture of girlhood/s through time: the projection of artistic or political ideals onto their pretty little heads. Blake saw Alice as representative of his ruralist ideals; I prefer to see Blake's Alice as a girl who, like one dropped into the hole of adolescence, troubles easy definitions. She is,

after all, constantly threatening to break through the white borders of her image, as in this moment when Alice is whisked up and ordered to run by the Queen of Hearts. Alice's raised arm gestures to the world outside the frame; don't look at me, it says – look *there.*

What happens if we do as we are told? As Alice's creation in and through the visual shows, depictions of girlhood/s in art seem to run away from their origins, shapeshifting in the eyes of their beholder. Maybe girlhood isn't a trap but, like the rabbit hole, a portal.

That teenage girls are so recognisable in portraiture through time, and yet not exactly *recognised,* speaks to their inherently ambiguous status. At once child and adult, innocent and sexual, protected and vulnerable, threatened and threat, in the shadows and spot-lit, girlhood occurs as a kind of ongoing moment between two reactive states. As well as having been channelled into work that is revealing of these ambiguities, this in-betweenness has also provided an opportunity to challenge the idea of what portraiture is really *for* to begin with.

Though we might be able to tell that these two paintings are of the same young woman, we probably wouldn't bet on it.

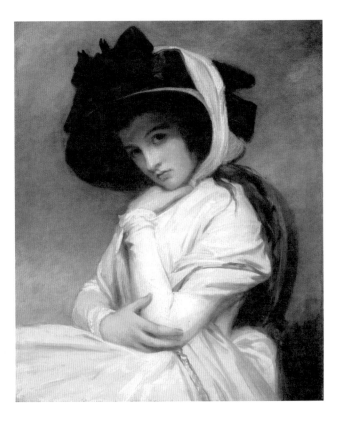

George Romney, *Emma Hart, later Lady Hamilton, in a Straw Hat*
c.1782-94, oil paint on canvas, 76.2 x 63.5, Huntington Art Collection

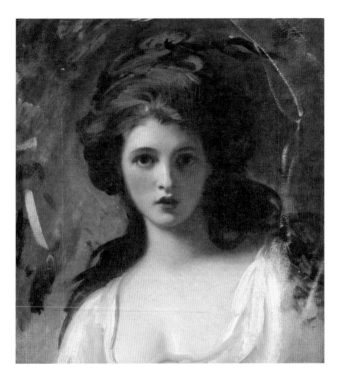

George Romney, *Emma Hart as Circe* 1782, oil paint on canvas,
53.3 x 49.5, Tate

They are two of many paintings Regency-era painter George Romney made of the teenaged Emma Hart (married name Hamilton), already described as 'London's biggest celebrity' by the time she found herself posing for the established artist. At this time of their meeting, she had already metamorphosised several times – from out-and-out poverty to table-dancing to out-of-wedlock pregnancy, to her latest status, at the time of these portraits, as lover to a wealthy gentleman – though it would be some years until her notable tenure as Admiral Nelson's great love. Both paintings might depict Hart aged seventeen, but it is in their framing that they diverge so tellingly.

In *Emma Hart, later Lady Hamilton, in a Straw Hat* c.1782–94 (also known as *Emma Hamilton as a Young Girl (aged seventeen)*), she is the picture of innocence. Her dress and straw hat are of a demure, everyday quality, and her pose is hunched, as if she is making herself smaller. In *Emma Hart as Circe* 1782, our picture of Hart rearranges itself: like a supermodel in close-up on a fashion cover, her gaze is direct and her lips a little open; her clothes, hair and backdrop are daubed, not concrete, mere draping for her beauty. If Hart is meant to be the seductive Greek goddess Circe here, there are no clues in the painting itself. Instead, Romney reduces his subject to the myth's core archetype: that of the predatory woman.

What came first: Hart's reputation as a seductress beyond her years, or Romney's depiction of her as such? When I look at her I think about the depictions of teenage celebrities of other eras: of Brooke Shields, portrayed as a sexual, knowing creature in Richard Avedon's infamous Calvin Klein advertising campaign, when she is just fourteen years old. I also note how, in the titles of both works, Hart is described 'as' something else: in each, she plays a role given to her by another. Romney's paintings of Hart tell us something about how girlhood always feels like a period of acting-*something*-out. Much later, the muse would become known for her 'attitudes': a kind of early performance art in which Hart played different characters in tableau for her friends to guess, like living versions of those portraits. Called 'the most extraordinary compound I ever beheld' by a contemporary diplomat, Hart's unpindownability was always inseparable from her own creative charge.

Characters from literature and legend have always stuck to perceptions of girlhood. The first time children come across figures subtly signposted as teenagers, for instance, is in bedtime fairy tales. The painters of the Pre-Raphaelite movement drew from this well of British storytelling, especially when it came to their cast of female subjects: I am thinking of much-reproduced paintings such as John William Waterhouse's *The Lady of Shalott* 1888 or John Everett Millais's *Ophelia* 1851–2.

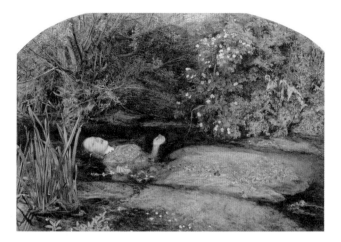

John Everett Millais, *Ophelia* 1851–2, oil paint on canvas, 76.2 x 111.8, Tate

The latter was praised at the time for its impressively accurate study of nature, an assessment that entirely leaves out the girl at its centre: Hamlet's romantic interest Ophelia, whose suicide by drowning occurs off-stage in Shakespeare's play. Drenched with symbolism right down to the flowers gently floating away from the subject's upturned palms – poppies for death, pansies for love in vain, daisies for innocence like a Marc Jacobs fragrance – the surface level of the painting's girl's-world aesthetics reverberate well into our own time. What GCSE artist hasn't conducted a photoshoot of their friend in the bath with all their clothes on, as Millais does with his model? The doomed, white, dead teenage girl continues to merit cultural fascination: Ophelia's blank gaze and horizontal body floats just downstream from Laura Palmer, 'wrapped in plastic' in David Lynch's *Twin Peaks*. But Millais's painting is also lasting because it speaks to the pleasure teenage girls take in *how things look*: the way girls today might describe objects as simply 'aesthetic' or, in the words of something I saw on TikTok, their need 'to romanticise absolutely fucking everything'.

The beautiful surfaces afforded by notions of girlhood have also been put to more explicit political use, as in Emma Soyer's recently discovered *Two Children with a Book* 1831.

Due to its dating and the depiction of the girls, Emma Soyer's painting was probably intended to promote abolition in the Caribbean. But what was most likely a practical commission at the time becomes charged with something else in the British gallery space where portraits of girls – and girls reading – are historically white. In situ, one kind of protest is fashioned as another: a certainly sentimental, but refreshingly tender, image of two young Black women (sisters, we think), where the elder safeguards the younger in an intimate space that feels out of its own time. Right now, on social media, many Black teenage girls are using photography, filmmaking, makeup and dress to issue a challenge to racist assumptions about who gets to represent softer, more romantic aesthetics. Viewed in this context, Soyer's airbrushed lens on these two girlhoods, and two lives that were once really lived, glows.

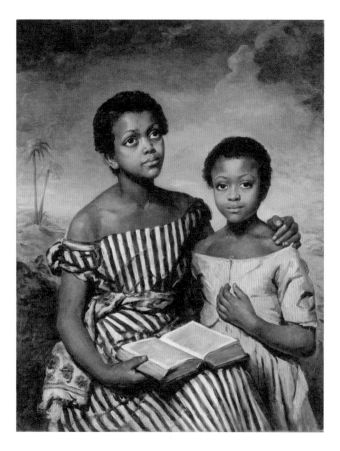

Emma Soyer, *Two Children with a Book* 1831, oil paint on canvas, 91.7 x 71.6, Tate

What about when source texts and political ideologies are set aside and girlhood is imaged simply 'as it is' – girls, 'as they are'? Historically, to be considered important enough to be visible *on one's own terms* was not something imaginable for girls, except those born into royalty or its adjacent elites. As such, these portraits speak as much to the status of daughterhood as girlhood.

Sofia Coppola, *The Virgin Suicides* (1999)

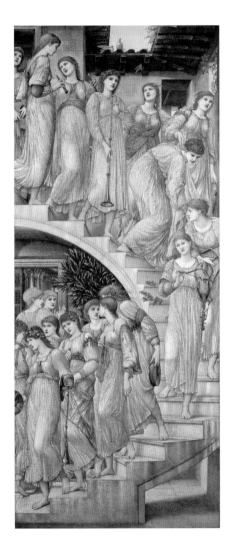

Edward Burne-Jones, *The Golden Stairs* 1880, oil paint on canvas,
269.2 x 116.8, Tate

Edward Coley Burne-Jones said of his nine-foot painting *The Golden Stairs* 1880 that it depicted simply 'a procession of girls coming down a flight of stairs'. As shown by the continued relevance of Sofia Coppola's film *The Virgin Suicides* (1999), such a procession is loaded with meaning for those of us watching them descend. To look a little closer at Burne-Jones's painting is to see interchangeably beautiful blanks solidify into individuals. Audiences at the painting's debut enjoyed spotting famous 'daughters-of' in the composition: Mary Gladstone, daughter of the Prime Minister; Frances Graham, daughter of the artist's patron William Graham; Margaret, Burne-Jones's own daughter; May Morris, daughter of William. One need only glance at today's magazine shelves and Instagram feeds to note the parallel with our own time, with the offspring of actors, pop stars, politicians and models anointed for hyper-visibility from puberty onwards. Still more than this, though, I feel a throughline from *The Golden Stairs*'s depiction of beauty to the indelible images of the debut film by Coppola – herself a notable daughter-of.

The Virgin Suicides has long been considered an *urtext* for girlhood: in the film – as in the Jeffrey Eugenides novel on which it is closely based – the months leading up to the deaths of five teenage sisters in the mid-1970s are recalled through the

memories of the men who once desired them. Everything hinges on prom night and, as they descend the staircase to greet the boys, we are told how the Lisbon girls' 'dresses and hairdos homogenized them'. The sisters' loose chitons – 'four identical shapeless sacks' – are one parallel with the mythical girls of *The Golden Stairs*, but it's the works' respective gazes that feel like they cross paths. Burne-Jones said he painted to create 'a beautiful romantic dream of something that never was, never will be – in a light better than any light that ever shone – in a land no one can define or remember, only desire.'[4] These artworks tell us something about girlhood by telling us something about the gaze that creates it – layers that teenage girls themselves are attuned to, and of which many men are, strangely, oblivious. I believe girls take pleasure in *The Virgin Suicides* for its beautiful images, but also because they are beginning to intuit that to come of age is to be surveilled, and to descend a staircase that seems to go on without end.

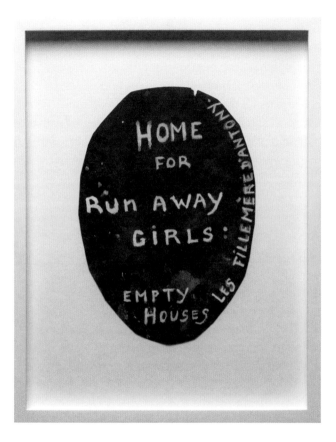

Louise Bourgeois, *Home for Runaway Girls* 1994, gouache on
sandpaper, 35.2 x 28, Tate

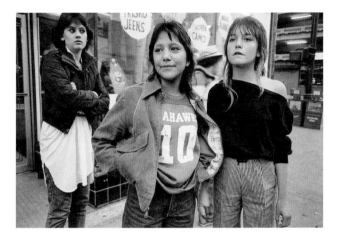

Mary Ellen Mark, *Tiny with her friends on Pike Street, Seattle* 1983

For many women artists in the twentieth century, such girlish aesthetics were to be interrogated, subverted, perhaps discarded altogether. Theirs is an energy of striving for a different kind of visibility, one without conditions. A feminist desire to unstick from the frameworks provided by men pervades the century: to trouble their borders. To run away.

The subject matter of girlhood – womanhood not yet domesticised – offers its own portal again.

'I was in effect a runaway girl. I was a runaway girl who turned out alright', Louise Bourgeois once said. Though she is preserved in the beloved image of a nattily dressed older woman, the artist's work can be seen as an eternal return to girlhood: she variously employs stained cotton dresses, embroidered fabrics and overstuffed baby-pink dolls as tools to undertake an archaeological dig on her subconscious. Such circling the past through artmaking recalls the writer Annie Ernaux, whose memories of adolescence also hover in her texts. In *A Girl's Story*, she writes of her first sexual encounter while working at a summer camp, aged sixteen, describing how certain films, images and texts trigger an 'interior collapse' that bring her viscerally back to that experience.

Louise Bourgeois's art gives me this same feeling of cracking open both the fragility and the

devouringness of my girlhood. It fascinates me that when Bourgeois runs away – as all artists must do to create – she cannot help but always return. Though we are not strictly in the arena of portraiture, Bourgeois's works feel like they are in conversation with all those *Portraits of Young Girls* who look out of their frames, back at us.

Take *Home for Runaway Girls* 1994. Painted to resemble a sign outside a boarding house, this work refers to a real home for unwed mothers that was in the artist's childhood home town. But Bourgeois also speaks here of her own identity as an artist, and specifically her memory of leaving Paris for New York as a young woman. Though her work is often associated with the trauma of girlhood, Bourgeois also gives space to the rebelliousness and the opportunity for creativity that this period allows us before the assumption of adult responsibility.

The mischievousness of Bourgeois's piece – its *entendre*, its everydayness – seems to speak to all the runaway girls who make it to gallery walls in the second half of the twentieth century, in the street photography of artists like Shirley Baker, Diane Arbus and Mary Ellen Mark. In Arbus's work, the girls are apparitions, child-adults either too large or little for their clothing (enter Alice, in frame again, drinking a potion). Mark's shots of

homeless kids in Seattle, meanwhile, grow into a body of work documenting one particular girl, Erin Blackwell, known to us as Tiny in Mark's original 1983 photo story for *LIFE* magazine as well as in the documentary *Streetwise* (1984) that followed. 'I wanna be really rich, and live on a farm, with a bunch of horses, which is my main best animal, and have three yachts, or more. And diamonds, and jewels, and all that stuff', fourteen year-old Tiny says in the film's voiceover, as we see her pixie-sized figure stand on the street waiting for men to pick her up for what the girls call 'dates' (though they are far from that). But we also see her twirling on the pavement, arms outstretched and giggling; or, in one of Mark's most evocative photographs, wearing a glamorous pillbox hat and a serious expression. The latter image works because in cosplaying adulthood, Tiny has found another way to become herself: Mark, the artist and stylist of this particular image, knows how this clothing suits her pride and her fervent dreaming of another life. Exuding a timeless and stylish appeal, Mark's subjects are nonetheless a record of young women at their most vulnerable. Theirs are girlhoods fondly remembered in art, and left behind by society.

Alice points outside the frame, Ophelia floats downriver, Burne-Jones's girls get their 12,000

steps, and Tiny and her friends run away – where is all of this going? At some point, outside the frame, well into the twentieth century, these daughters-of and sisters-of and muses-of begin to tell their own story.

This is when girls finally step through the Looking Glass – or pick up a camera. One, Francesca Woodman, picks hers up in 1972.

Another, who is both me and not me, picks hers up in 2007.

Francesca Woodman is a turning point for representations of girlhood not because she is the first teenage girl who ever picked up a camera, but because she is the first to see herself *as an artist*.

That Woodman is so complete in her references – roaming surrealism, gothic literature and early experimental photography – from her first compositions aged thirteen continues to provoke amazement in critics. Yet it makes total sense to anyone who has gone through the peculiar creative energy of girlhood, a period in which the necessary isolation, spare time and insecurities of adolescence lead to all kinds of visual experiments with much the same tools, in much the same rooms.

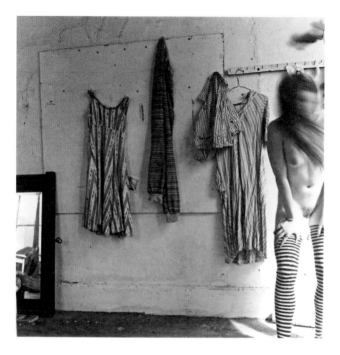

Francesca Woodman, *Untitled, Providence, Rhode Island* 1975–8, photograph, gelatin silver print on paper, 10.9 x 10.9, Tate

The author in her bedroom, 2007

Woodman is a magician. She is a mere imprint on the floorboards like a cordoned-off crime scene (*Untitled, Providence, Rhode Island* 1976); she is a single leg kicking out from a blur of body and wallpaper (*House #3, Providence, Rhode Island* 1976). Much has been made of these disappearing acts: the blurred presence-in-absence of her figure, the way her body always threatens to become vapour inside the frame. As the writer Deborah Levy has said, Woodman is interesting *because* we have to try and find her. Of course, that the critical gaze has often focused on the way Woodman disappears before our eyes has a lot to do with the fact of her death. When she threw herself out of a loft window aged twenty-two, she became crystallised in her girlhood. But, as any girl knows, the camera lens is a tool for self-actualisation not because it makes for a truthful record of our interior, but because it is a gateway to different selves.

That all these potential selves, layered and perpetually in motion, may themselves add up to a kind of blurring doesn't mean girls want to disappear. Instead, such experiments feel like our way of saying 'I was here' – but also, importantly, 'I am not legible as one thing.' This is photography as world-making, a language all girls understand. It's no coincidence that, looking at images made

and circulated by girls online, we see the same experiments with presence and absence, size and scale, as in Woodman's work. It might be the Bourgeois-like dresses on hangers, but this image feels related to looping Reels in which girls snap their fingers to switch their outfits from oversized to skin-revealing, or the various references shared by teenage girls that feature unmade beds, and shadows of bodies on the ground (*I was here*).

To call Woodman's photographs proto-selfies, then, is to do them a disservice. In their romantic atmosphere and spirit of technical play, they exist on a continuum not with optimised feminine self-presentation, but with the filmmaking of apps like TikTok, where girlhoods are circulating not only farther than ever before but faster, and with greater impact, than I could have ever imagined when I arranged my own body before the camera in the mid-2000s. Less known than her photography, Woodman was beginning to incorporate video work into her practice before her death. In one, we see her gleeful reaction to the imprint of her body on the floor, in reality a trick achieved with leftover bakery flour. Laughing aloud, she sounds just like a girl who has perfected a difficult dance for her phone camera.

While artists like Woodman and Bourgeois scraped against their respective frames, frenzied in their determination to be seen, self-portraits today amount to a social requirement for girls. But if many of them possess a preternatural knowledge of art history, they also have a desire to interrogate the nature of its subjection. One group driven by this desire was the Art Hoe Collective of the mid-2010s, a POC Tumblr community fuelled by a love of art, as well as a desire to see themselves within it.

Like Woodman, the girls of Art Hoe weave a world of references to other artists in their creations; unlike her, they make that insertion into the art historical narrative starkly explicit. These self-created images offer, in the words of co-founder Mars, a place for these young women 'to call home', but also a redress to the commercial use of art references to exploit teenage girls of colour. I'm thinking of imagery like the artwork for Bow Wow Wow's 1981 debut album, for which fourteen-year-old singer Anabella Lwin was photographed nude in the style of Édouard Manet's *Le Déjeuner sur l'herbe,* while her male bandmates remained clothed. The Art Hoes play on this same patriarchal art historical gaze to insert themselves, *as themselves,* within it: a reclamation of their representation that occurs pixel by pixel, and layer by Photoshop layer.

Found image, source unknown

Trying to rediscover them in the writing of this essay, I was met with broken links: the original community, as girls tend to, have grown out of it. The fact of choosing when to jump off from an aesthetic you don't recognise any more is its own coming of age.

Francesca Woodman was once described by her former employer as having 'skin inside-out'; it was like she had no layer of protection, because she had no community. Contemporary portraitists and self-portraitists, such as Rene Matić, are motivated to make work that radiates with the personalities of the individuals with whom (not just *of* whom) it is being made – in Matić's case, at the intersection of their Black British heritage, and the queer community they later found.

We are very far here from the world of portraiture this book opened with. These are not figures who have had to sit uncomfortably for hours, freezing into an ideal pose until their 'creator' says they are through with them. Instead, Matić's composition is traced along personal lines, with an intimacy that draws us into the generative mess of modern-day girlhood/s. The pair's clothing as the artist's friend Chidera Eggerue does their hair expresses their individual style, politics and gender expression: Matić, who is non-binary, wears a nose ring and vintage ringer t-shirt from the activist group

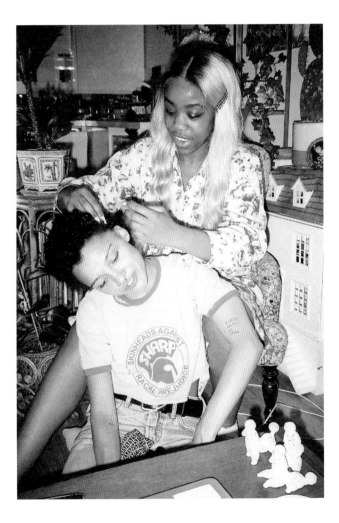

Rene Matić, *Chiddy Doing Rene's Hair 2019* 2019, inkjet print,
40 x 27, Tate

Skinheads Against Racial Prejudice, and I love
the puncturing detail of Eggerue's sparkling kirby
grip, its PERIOD like a full-stop. Meanwhile, a doll's
house in the background (and ceramic poodles in
the foreground) nod to all those nice things that
little girls are supposedly 'made of'. With its record
of changing hair colours, pastel eyeshadows and
nights out, Matić's photography often tells a story
of the pleasure taken in girlish aesthetics by queer,
trans and non-binary communities; here, as in the
best photographs, we've entered a moment that
feels like it is still occurring, that's ongoing and
irreducible, like best friendship.

Here and elsewhere, Matić's work speaks of
community through image-making. These are not
photographs which need to intercept pre-existing
spaces; they create their own. Their own kind of
wonderland. Matić's subject is themself and their
coming of age, but it is a self that recognises the
power of these points of connection and tends to
them with care.

When work like Matić's hangs on major gallery
walls, there is no need for girls who see it to do all
the work to reconnect such pictures to the world
from which they come. The leap is no longer as
great, the distance, not so far.

At one point in the journey that Alice, the art-made adolescent, makes through an absurd world, we are told: 'SOMEHOW OR OTHER, THEY BEGAN TO RUN.' It also feels true that, today, somehow or other, the girls might not always have to. The spaces that they have created for themselves – online spaces, as well as physical ones – offer their own kind of home for runaway girls. The girls that were always everywhere.

Endnotes

1 My use of the term 'girlhood/s' reflects my definition of the term as something both universal, and different for each of us who experience it: never only one or the other, and always inclusive of LGBTQ+ youth.

2 Saidiya Hartman, *Wayward Lives, Beautiful Experiments: Intimate Histories of Riotous Black Girls, Troublesome Women and Queer Radicals*, London 2019.

3 Although this text's focus is the character Alice as represented by artists, it should be noted that the nature of Carroll's own intentions toward the child Alice Liddell have been much debated and continue to be re-evaluated.

4 Josceline Dimbleby, *A Profound Secret: May Gaskell, Her Daughter Amy, and Edward Burne-Jones*, London 2004.